MAGICAL LANDSCAPES
COLORING BOOK

MIRYAM ADATTO

Dover Publications, Inc.
Mineola, New York

These thirty-one magical landscapes feature a variety of panoramas right out of fantasy land. Each meticulously rendered image is highly detailed, making this collection the perfect addition to Dover's *Creative Haven* series for the experienced colorist. The intricate designs are perfect for experimentation with different media and color techniques. Plus, the perforated, unbacked pages make displaying your finished work easy!

Copyright
Copyright © 2016 by Dover Publications, Inc.
All rights reserved.

Bibliographical Note
Magical Landscapes Coloring Book is a new work,
first published by Dover Publications, Inc., in 2016.

International Standard Book Number
ISBN-13: 978-0-486-79951-3
ISBN-10: 0-486-79951-4

Manufactured in the United States by RR Donnelley
79951403 2016
www.doverpublications.com

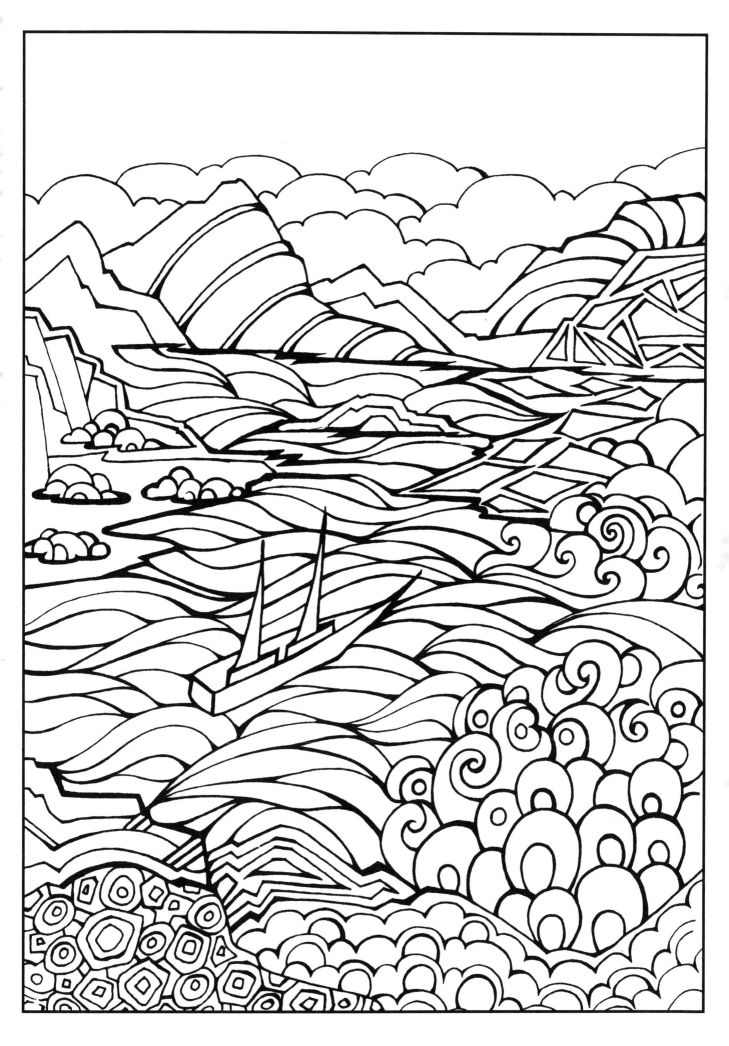

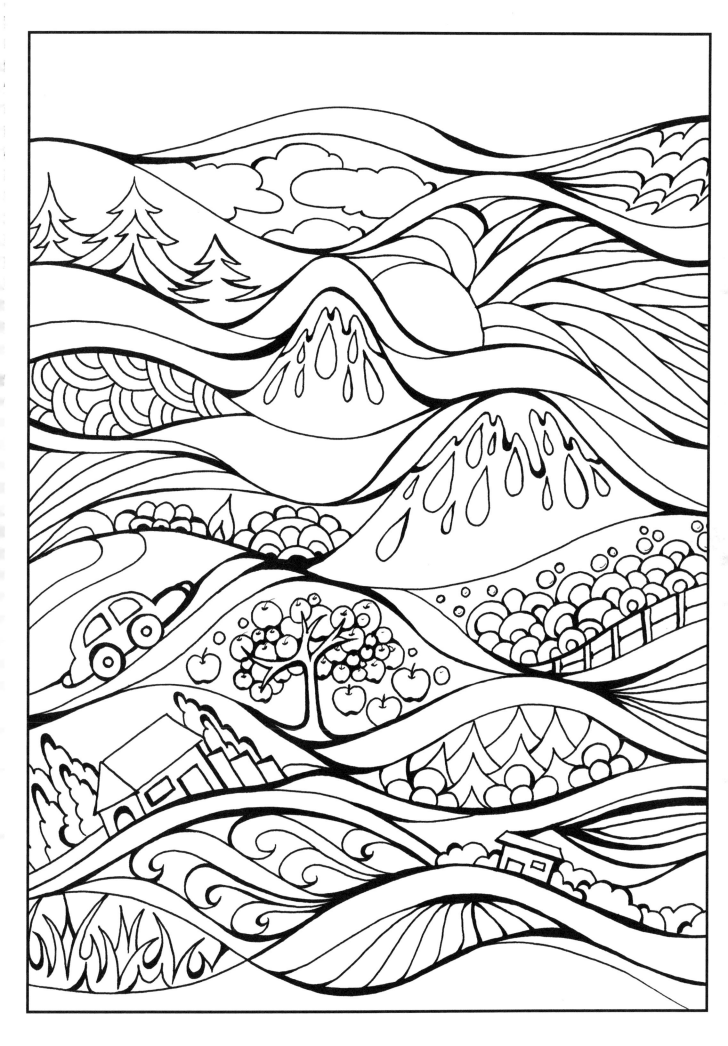

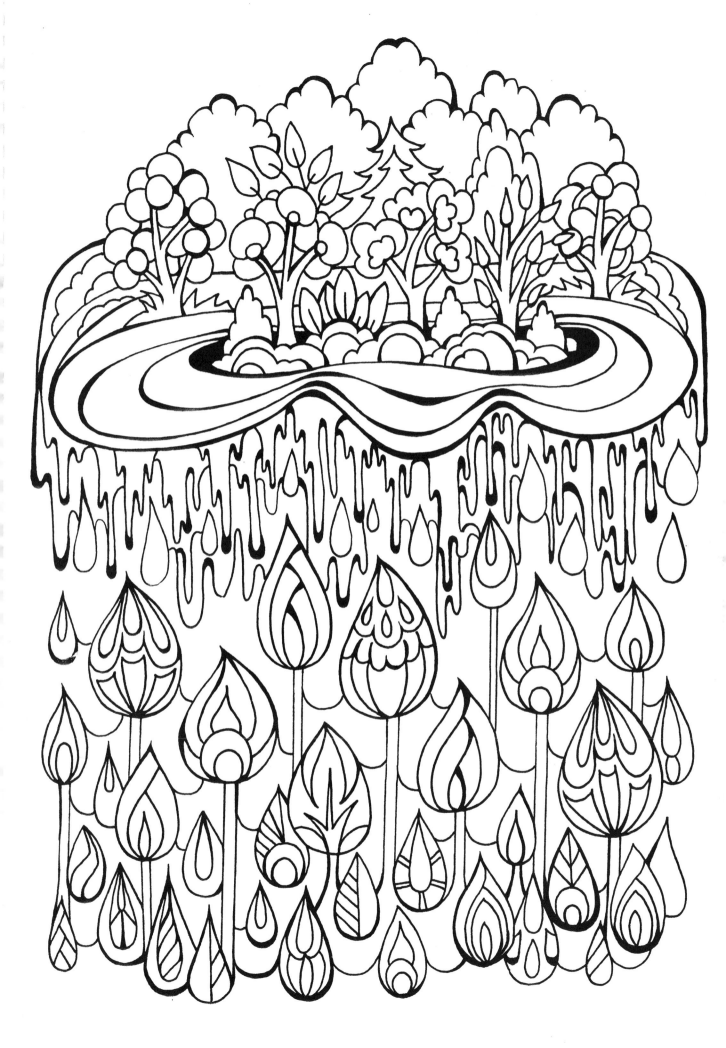

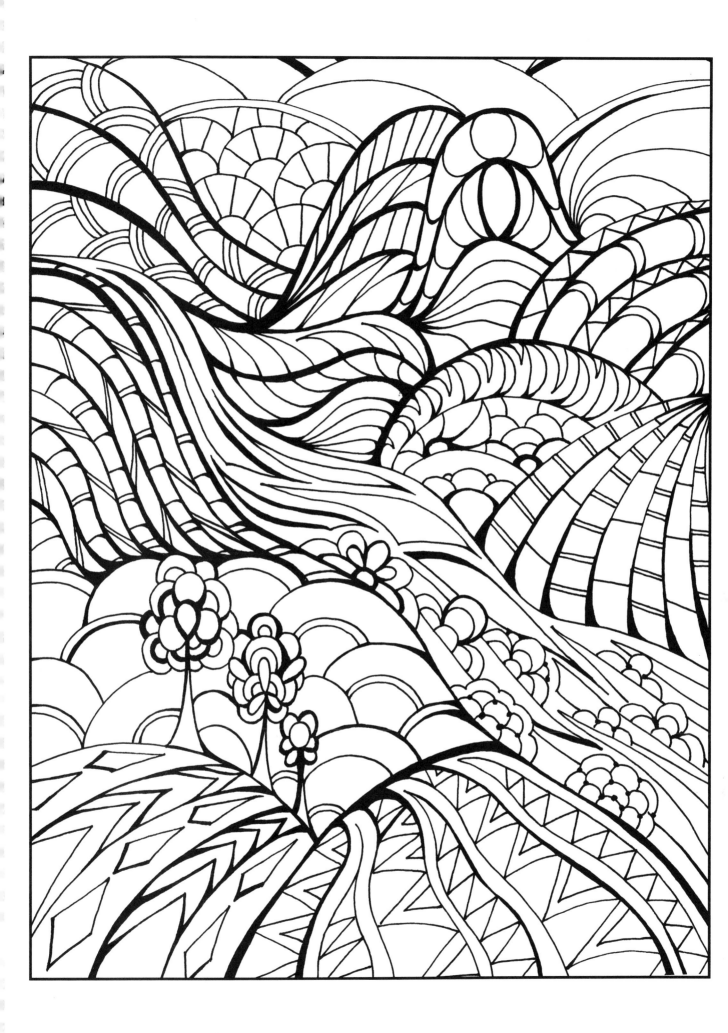

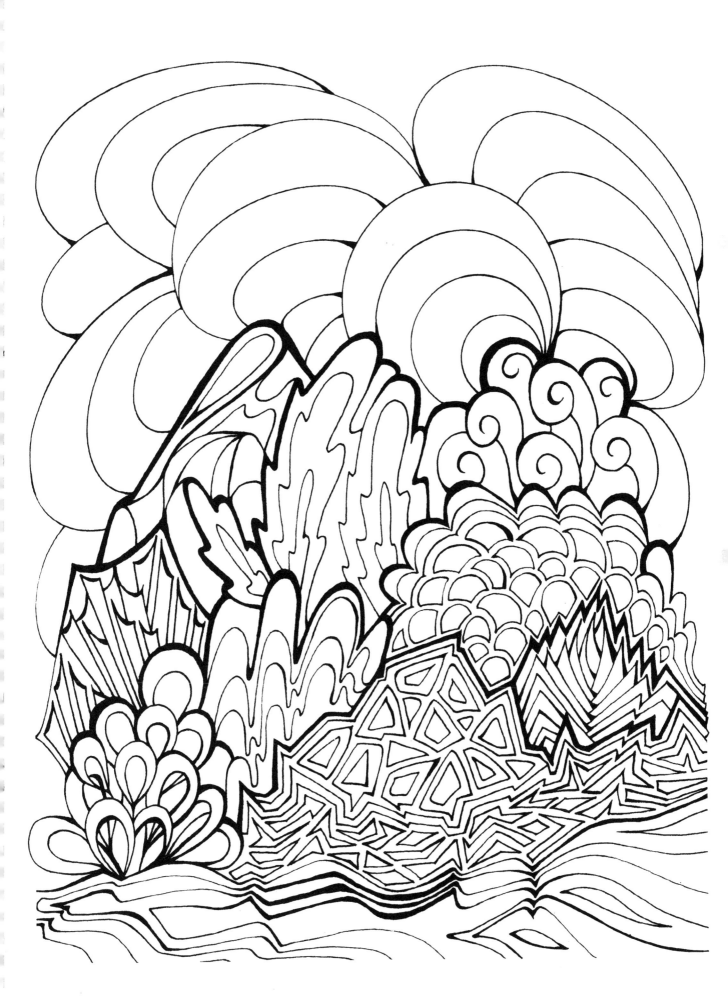

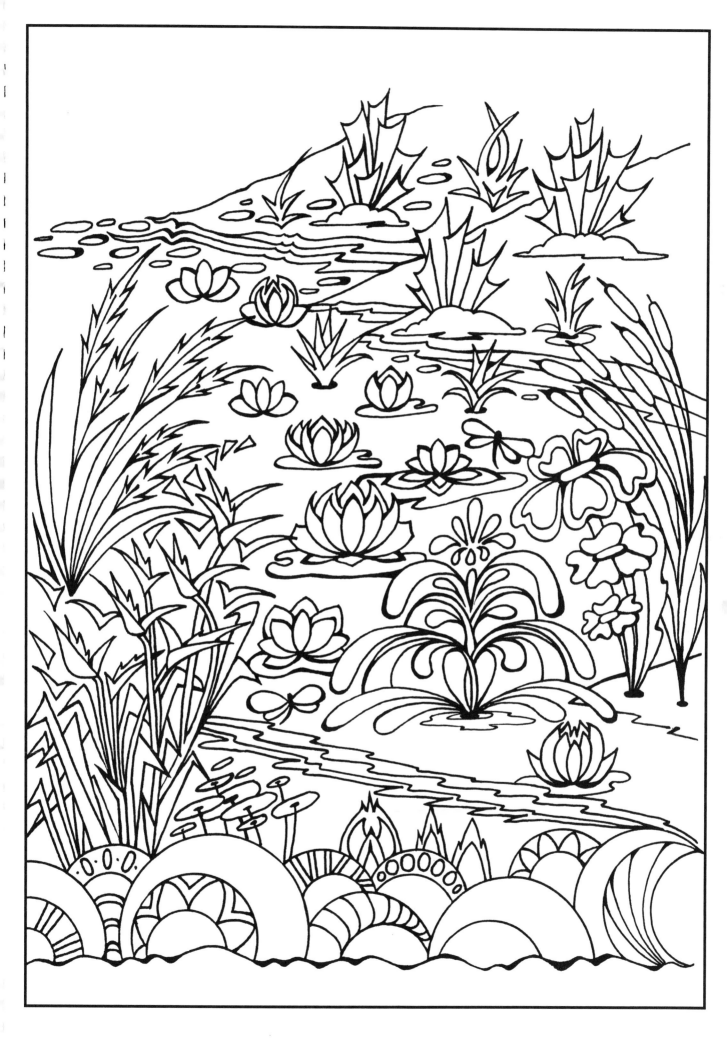

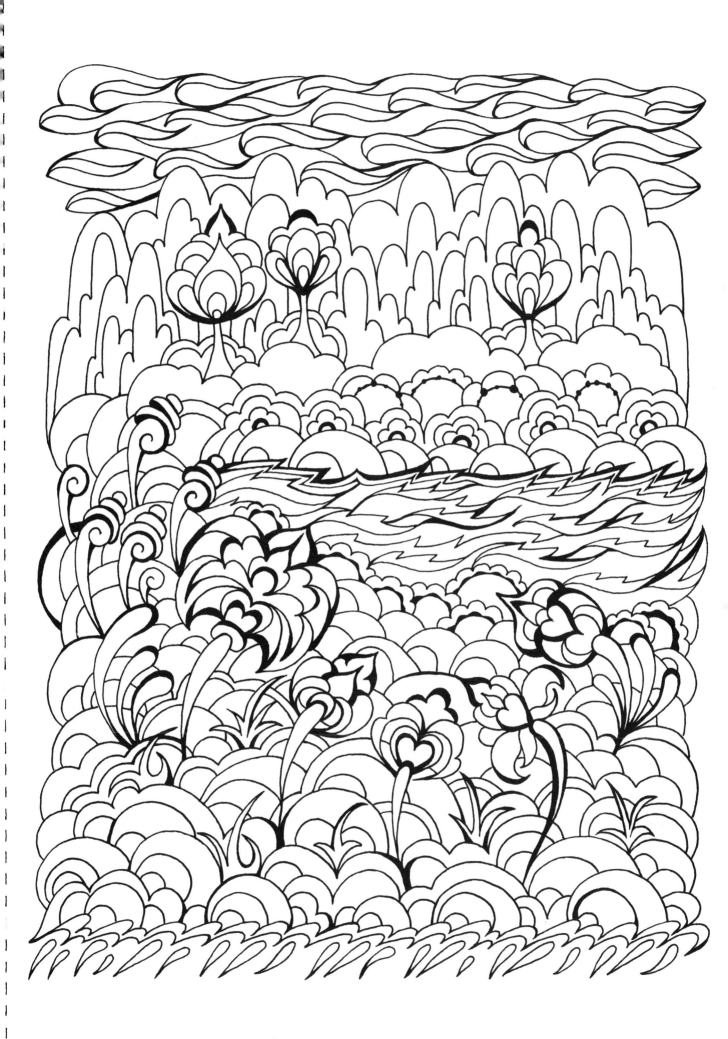

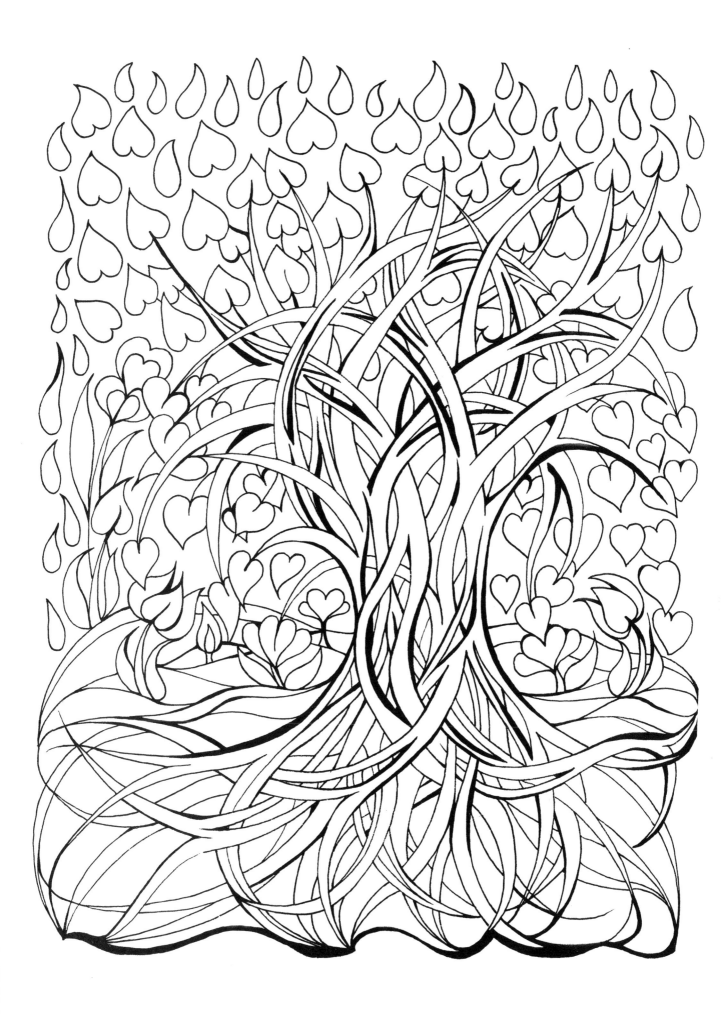

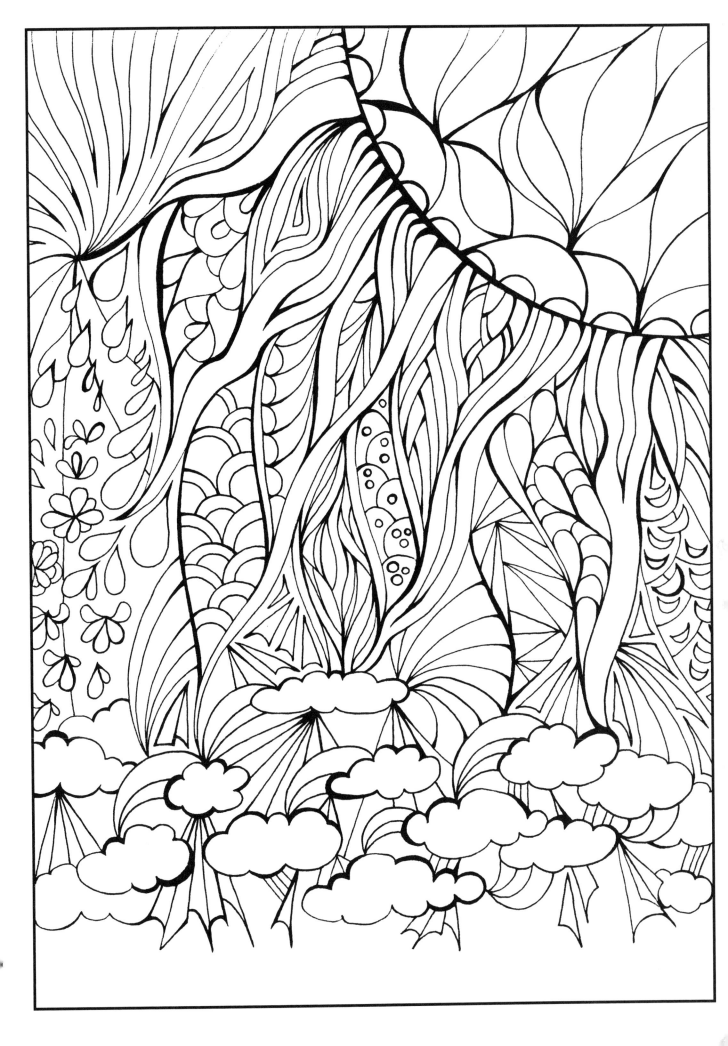

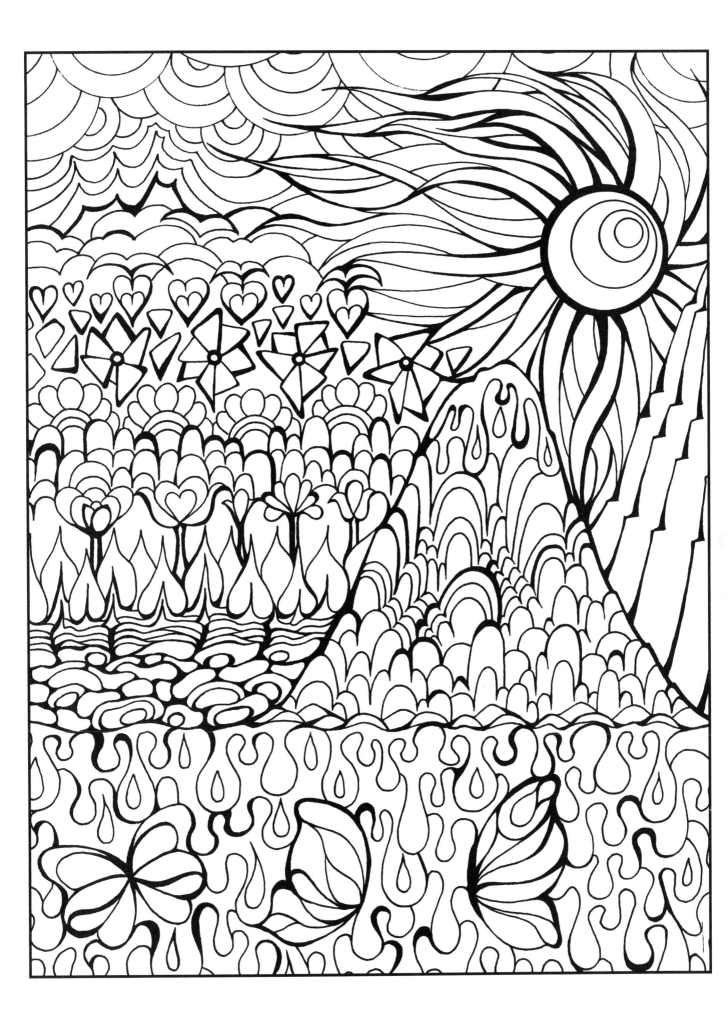

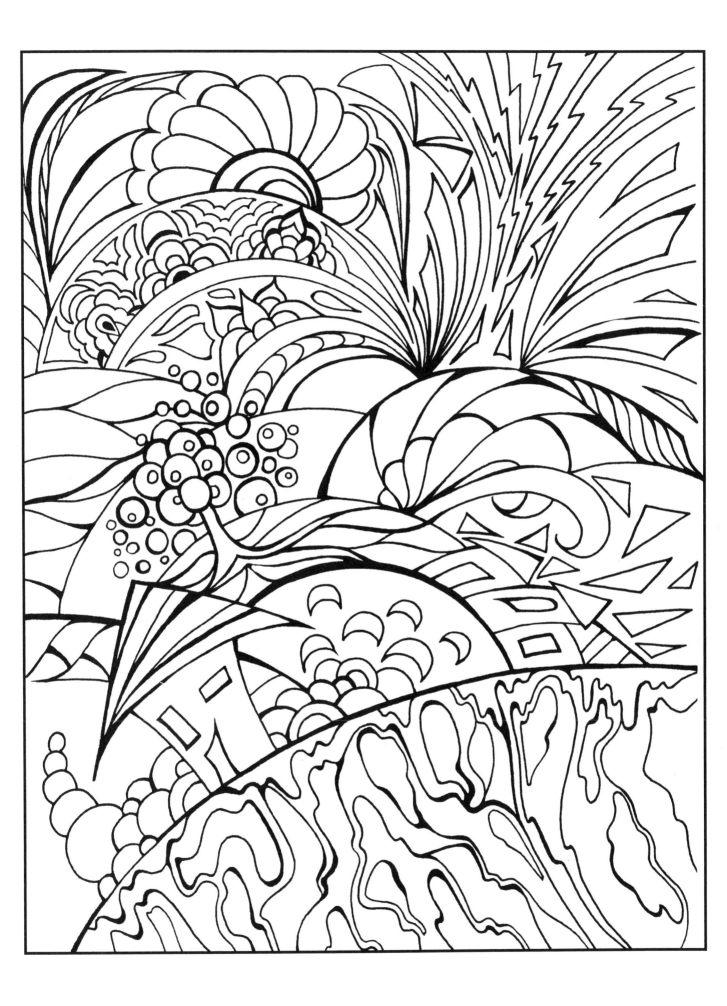

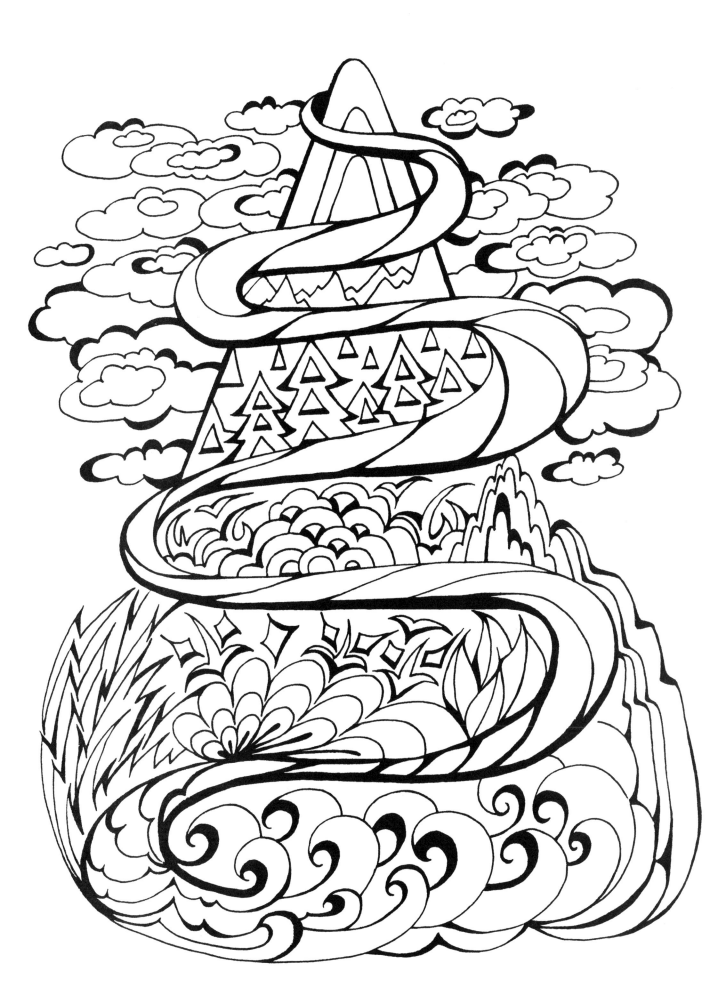

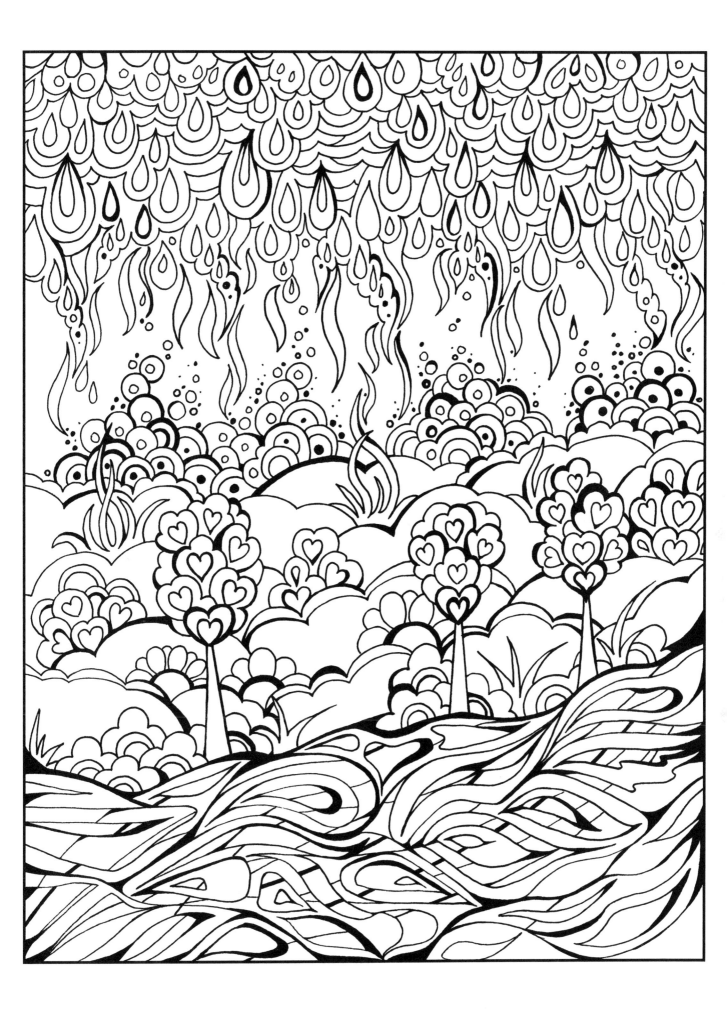

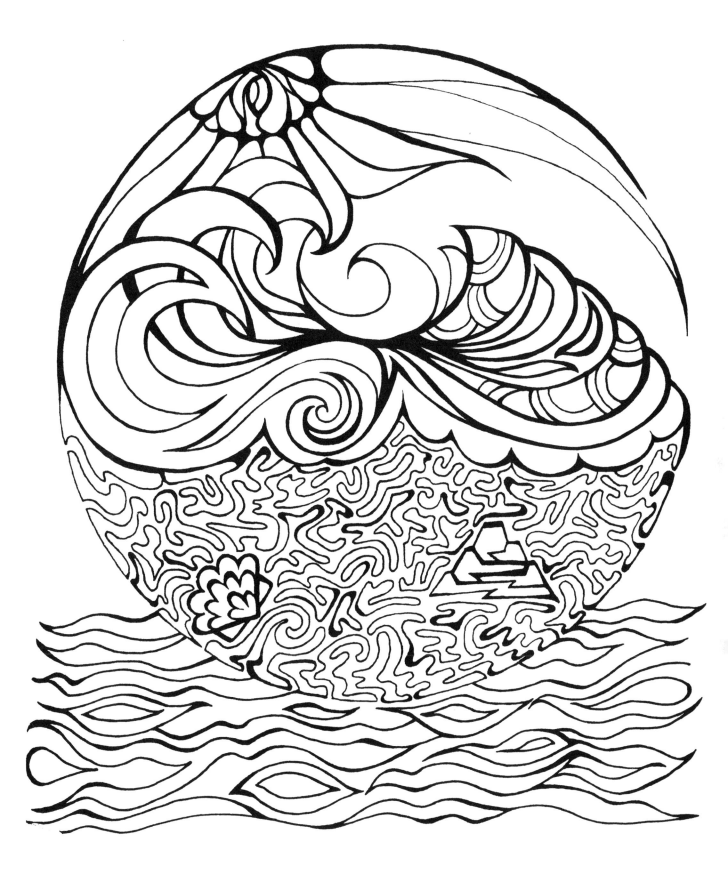

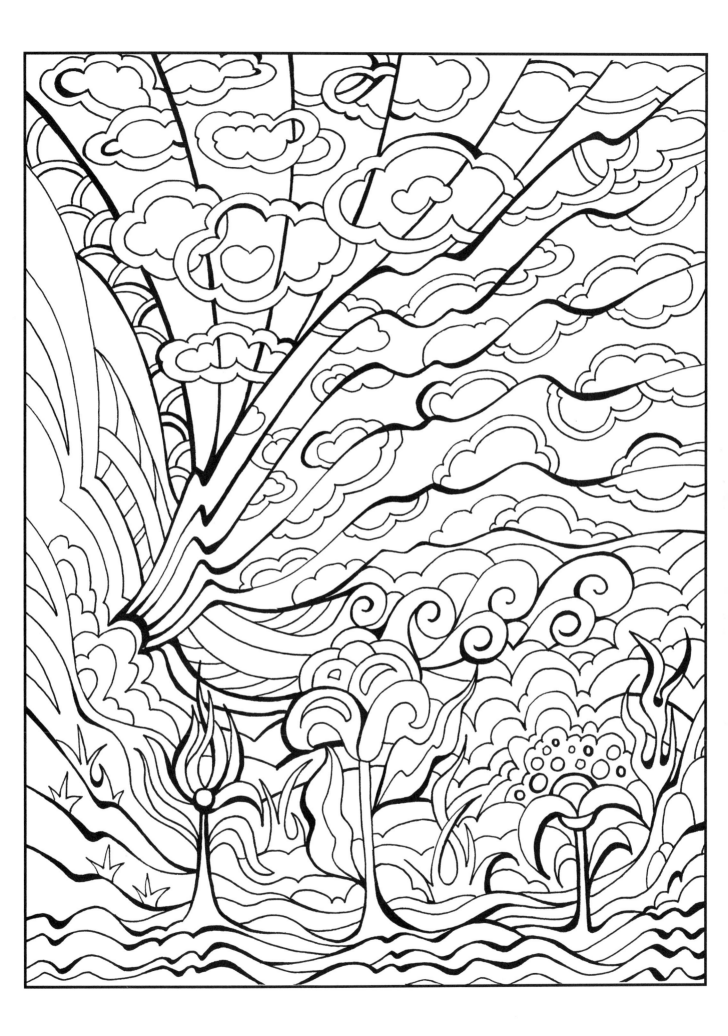

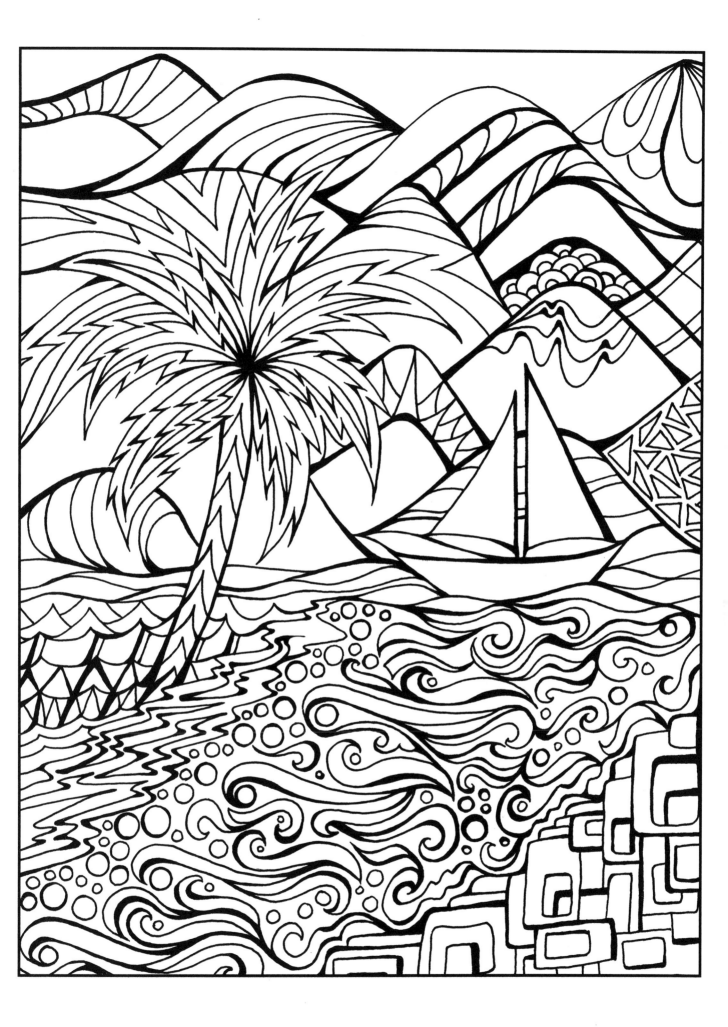

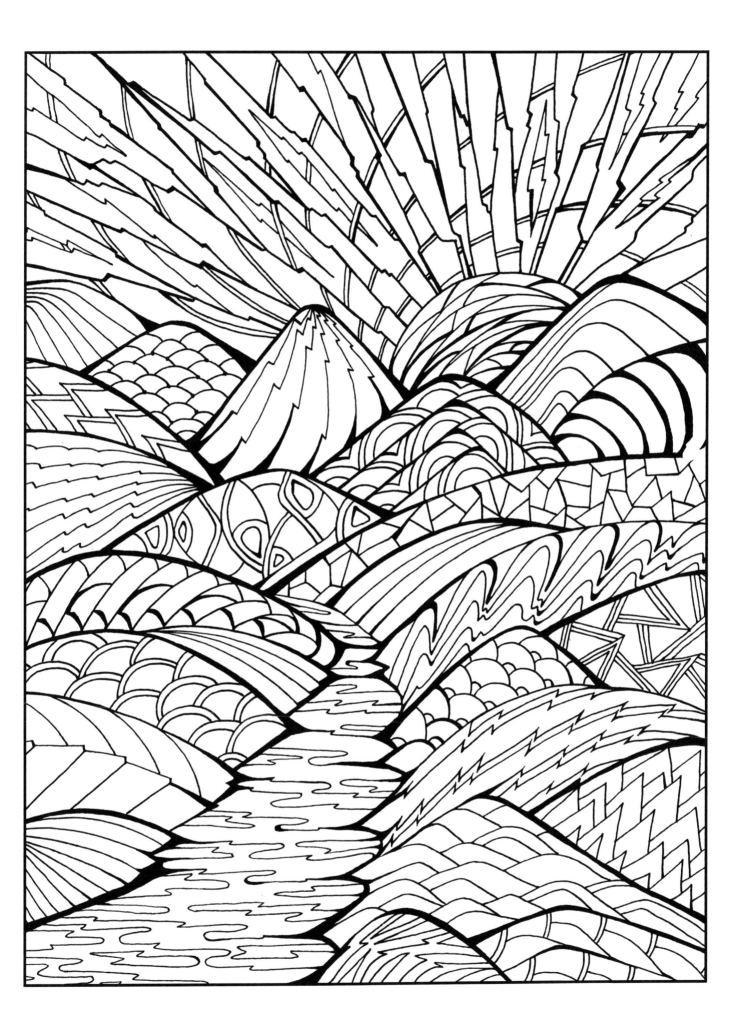

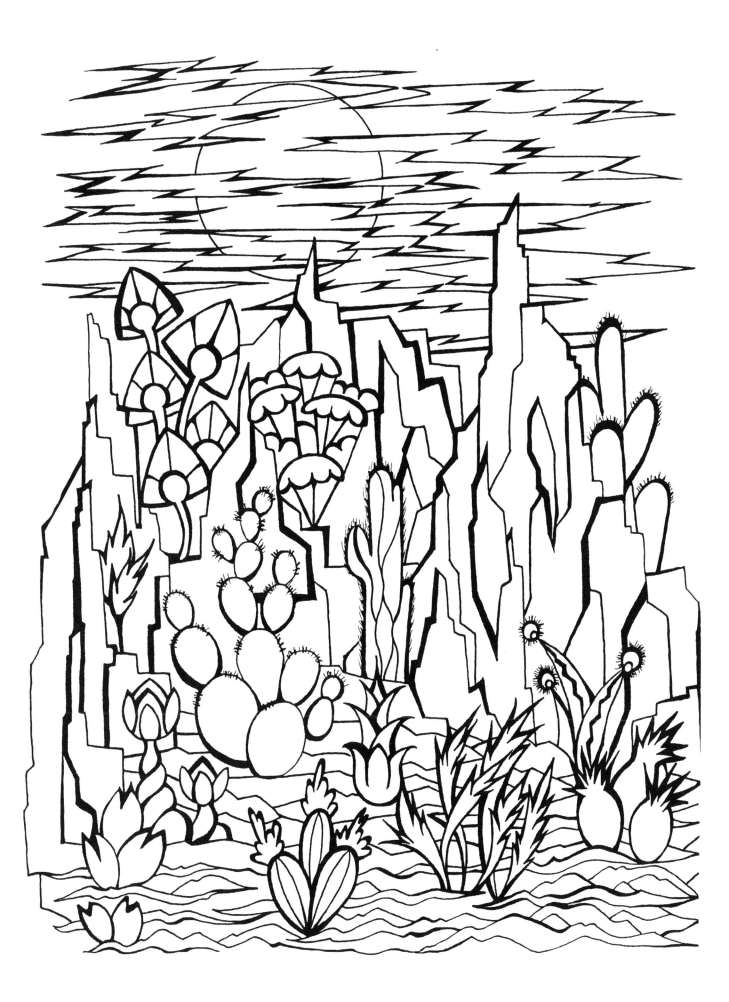

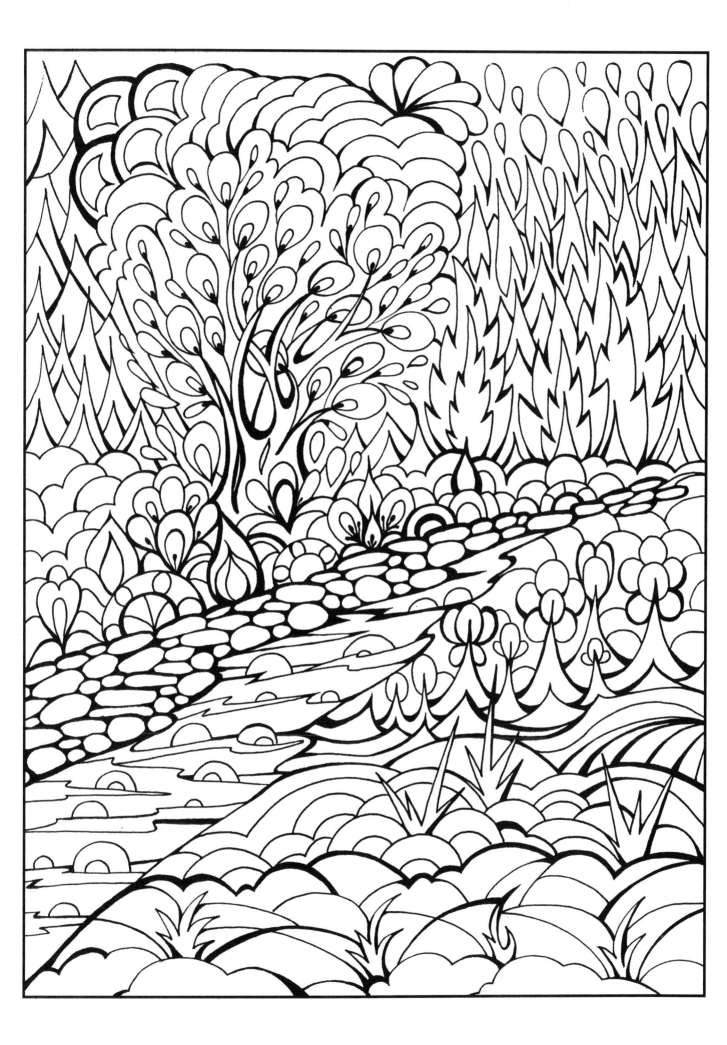

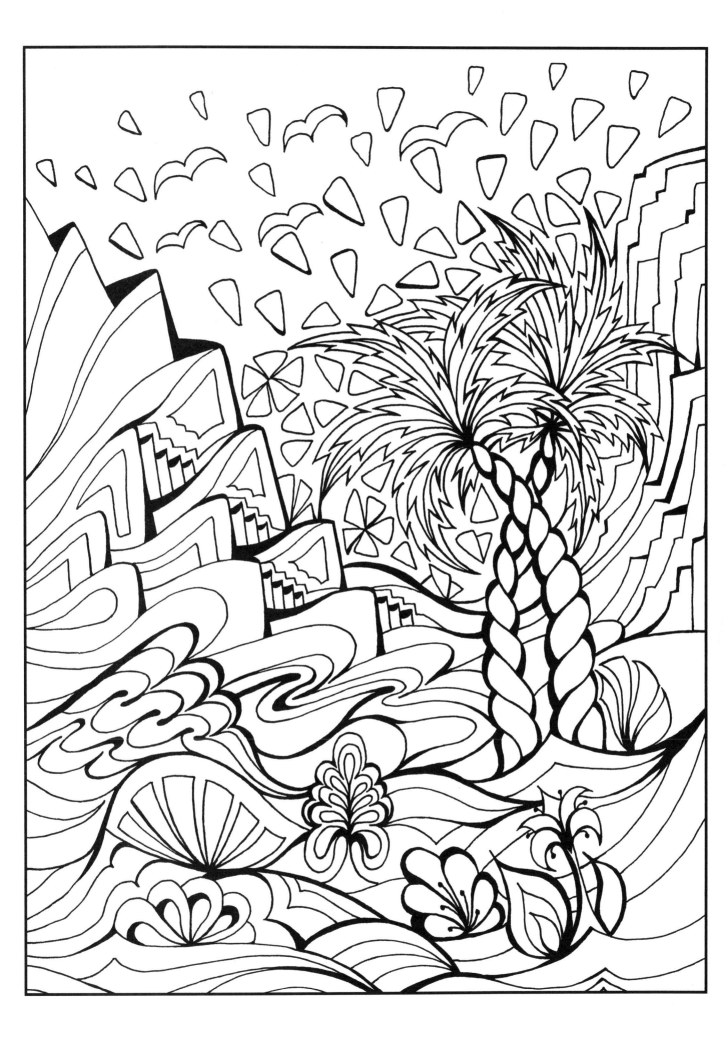

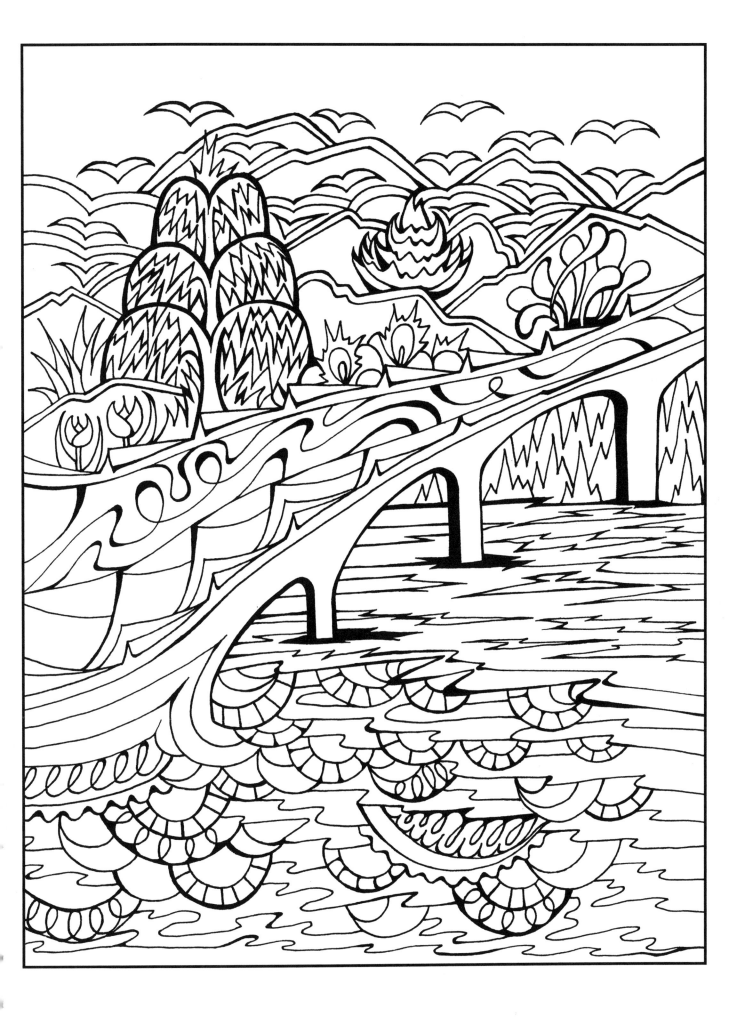

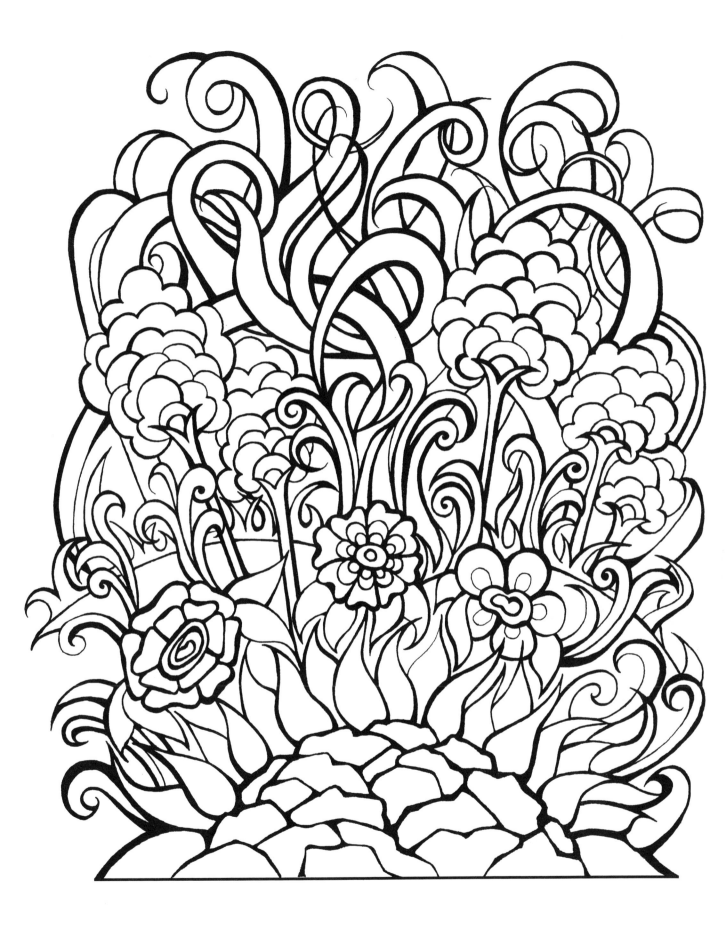

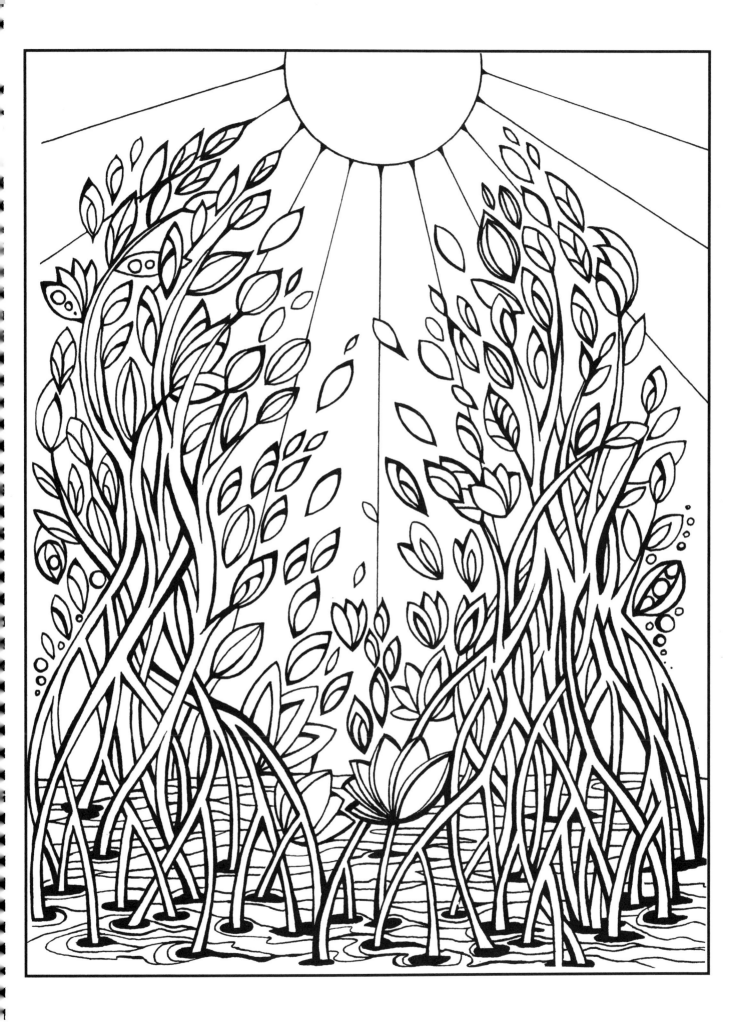

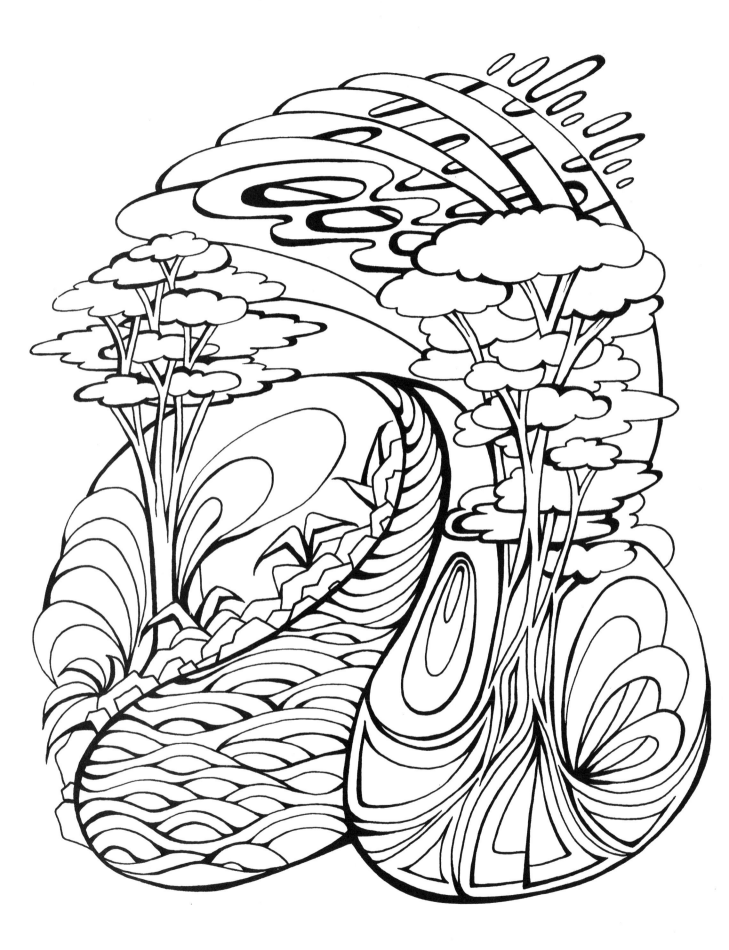

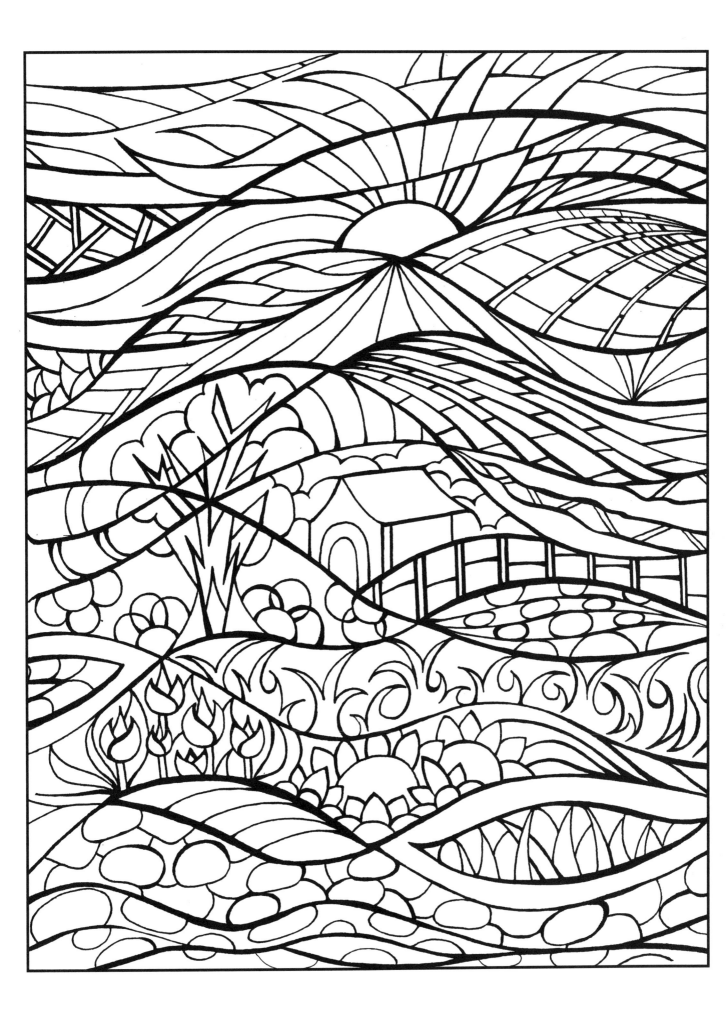

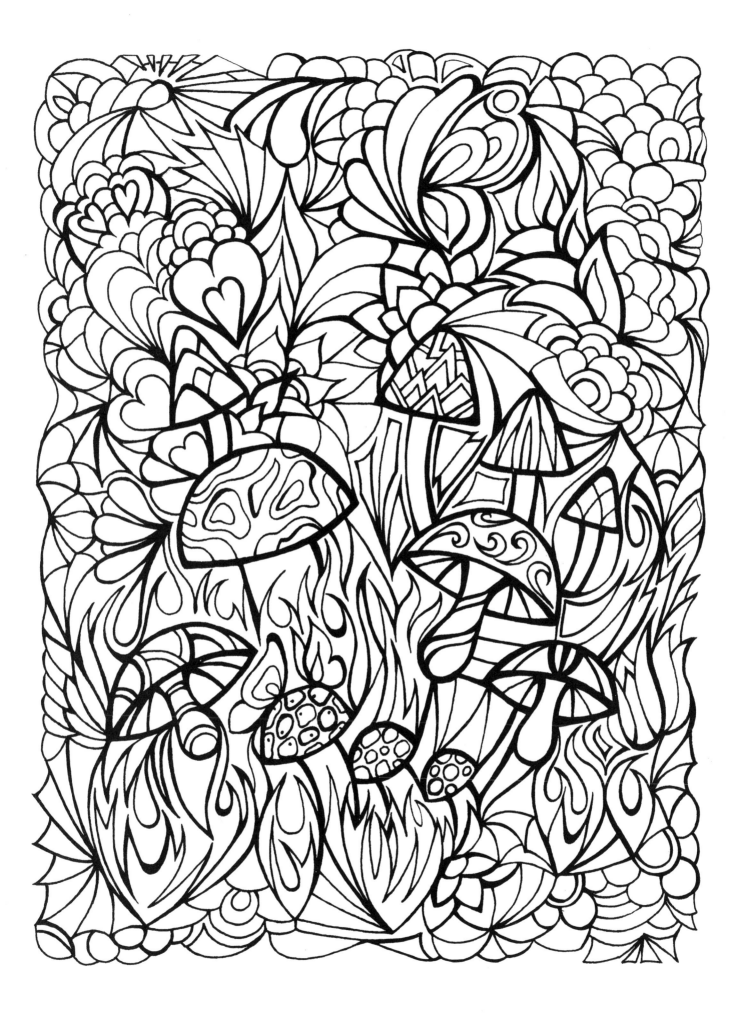

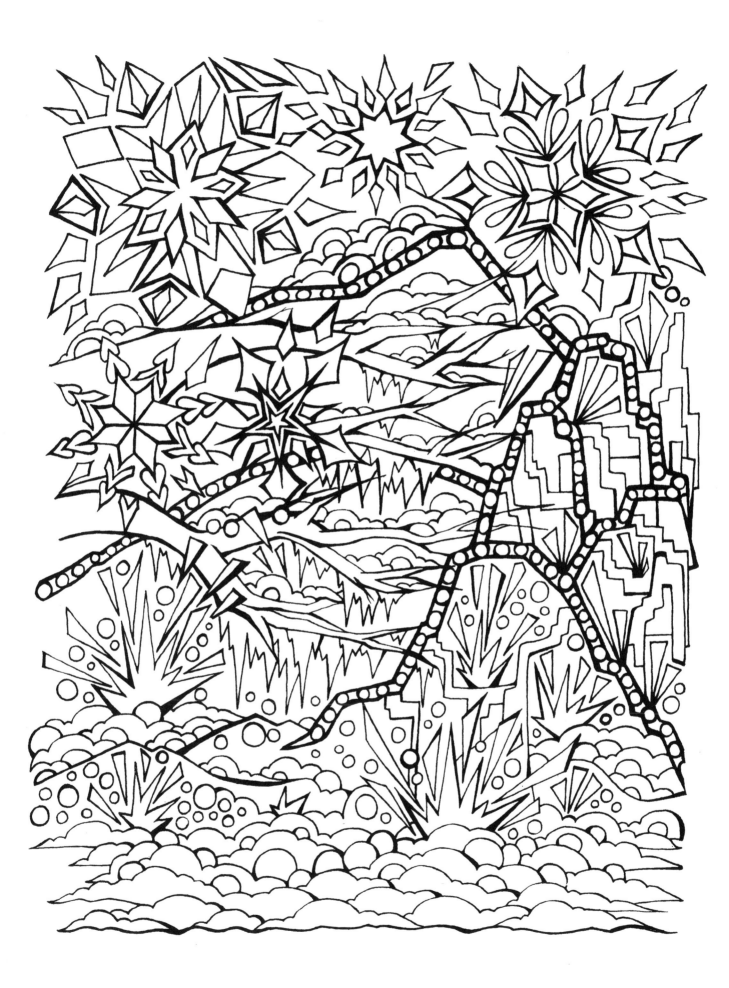

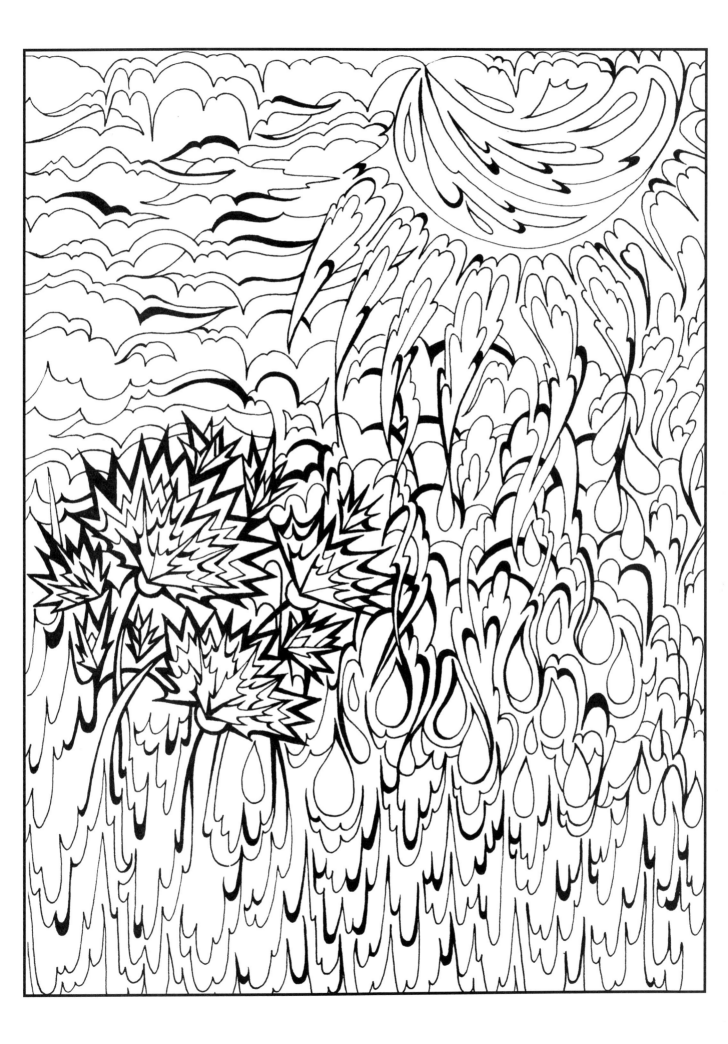

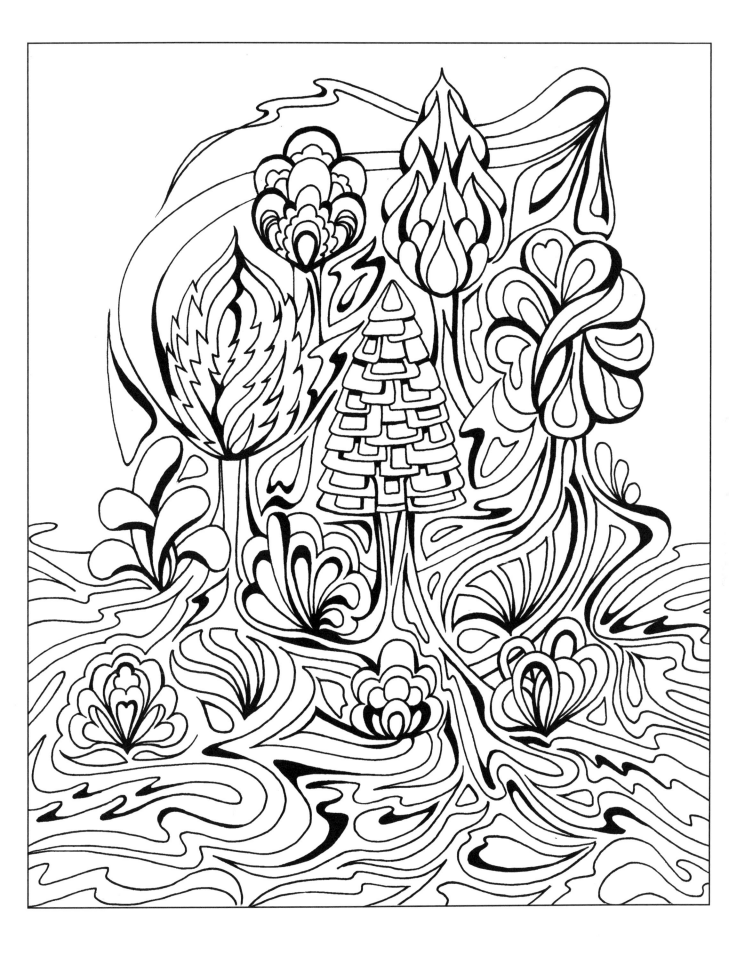

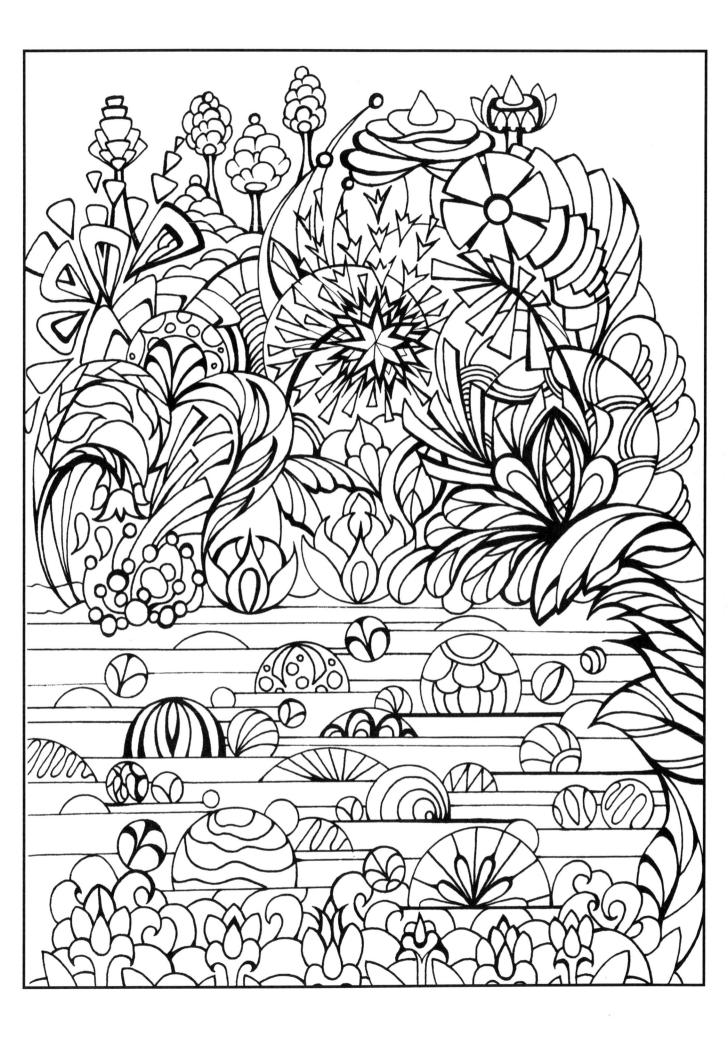

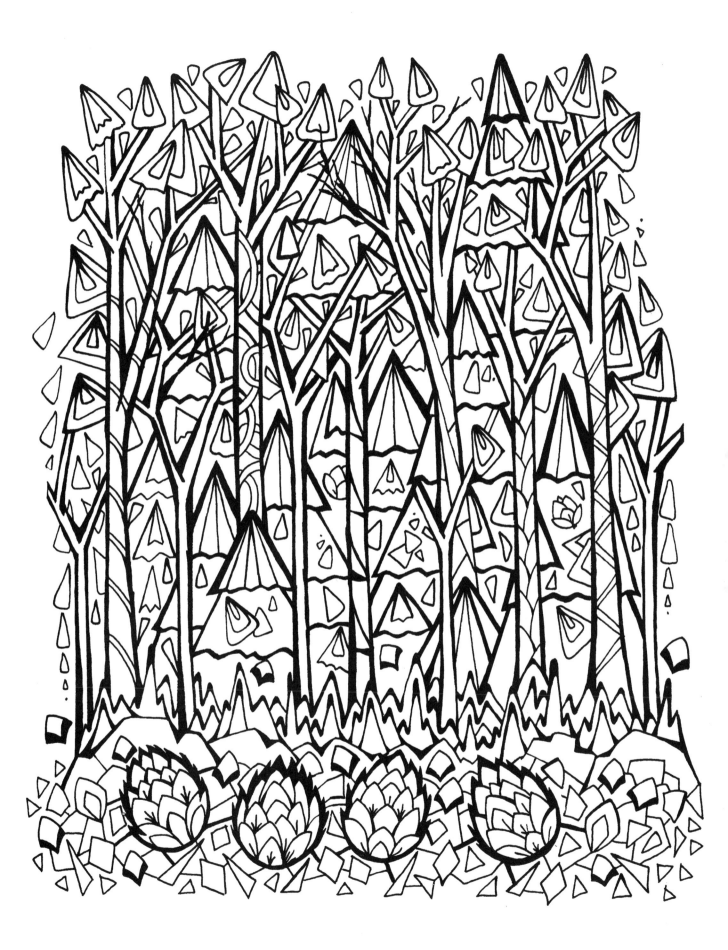